T0378418

Drawing Cute Animals Shape by Shape

Drawing Cute Animals Shape by Shape

Create Cartoon Animals with Circles, Squares, Rectangles, and Triangles

Get Creative 6

Christopher Hart Books for KIDS

Get Creative 6
An imprint of Mixed Media Resources LLC
19 W. 21st St., Suite 601
New York, NY 10010

Senior Editor
PAM KINGSLEY

Creative Director
IRENE LEDWITH

Chief Executive Officer
CAROLINE KILMER

President
ART JOINNIDES

Chairman
JAY STEIN

 My sincere thanks go to Art Joinnides, Carrie Kilmer, Pam Kingsley, and Irene Ledwith.

Copyright © 2025 by Art Studio LLC

All rights reserved. No part of this publication may be reproduced or used in any form or by any means—graphic, electronic, or mechanical, including photocopying, recording, or information storage-and-retrieval systems—without permission of the publisher.

The written instructions, photographs, designs, projects, and patterns are intended for the personal, noncommercial use of the retail purchaser and are under federal copyright laws; they are not to be reproduced in any form for commercial use. Permission is granted to photocopy for the personal use of the retail purchaser.

Printed in China

1 3 5 7 9 10 8 6 4 2

First Edition

Library of Congress Cataloging-in-Publication Data
Names: Hart, Christopher, 1957- author.
Title: Drawing super cute animals shape by shape: learn to draw over 100 adorable animals step by step from simple shapes / Christopher Hart.
Description: First edition. | New York: Get Creative 6, [2025] Includes index.
Identifiers: LCCN 2024041338 | ISBN 9781684620890 (paperback)
Subjects: LCSH: Animals in art—Juvenile literature. | Drawing--Technique—Juvenile literature.
Classification: LCC NC780 .H2582 2025 | DDC 743.6—dc23/eng/20240928
LC record available at
 https://lccn.loc.gov/2024041338

WHAT'S INSIDE

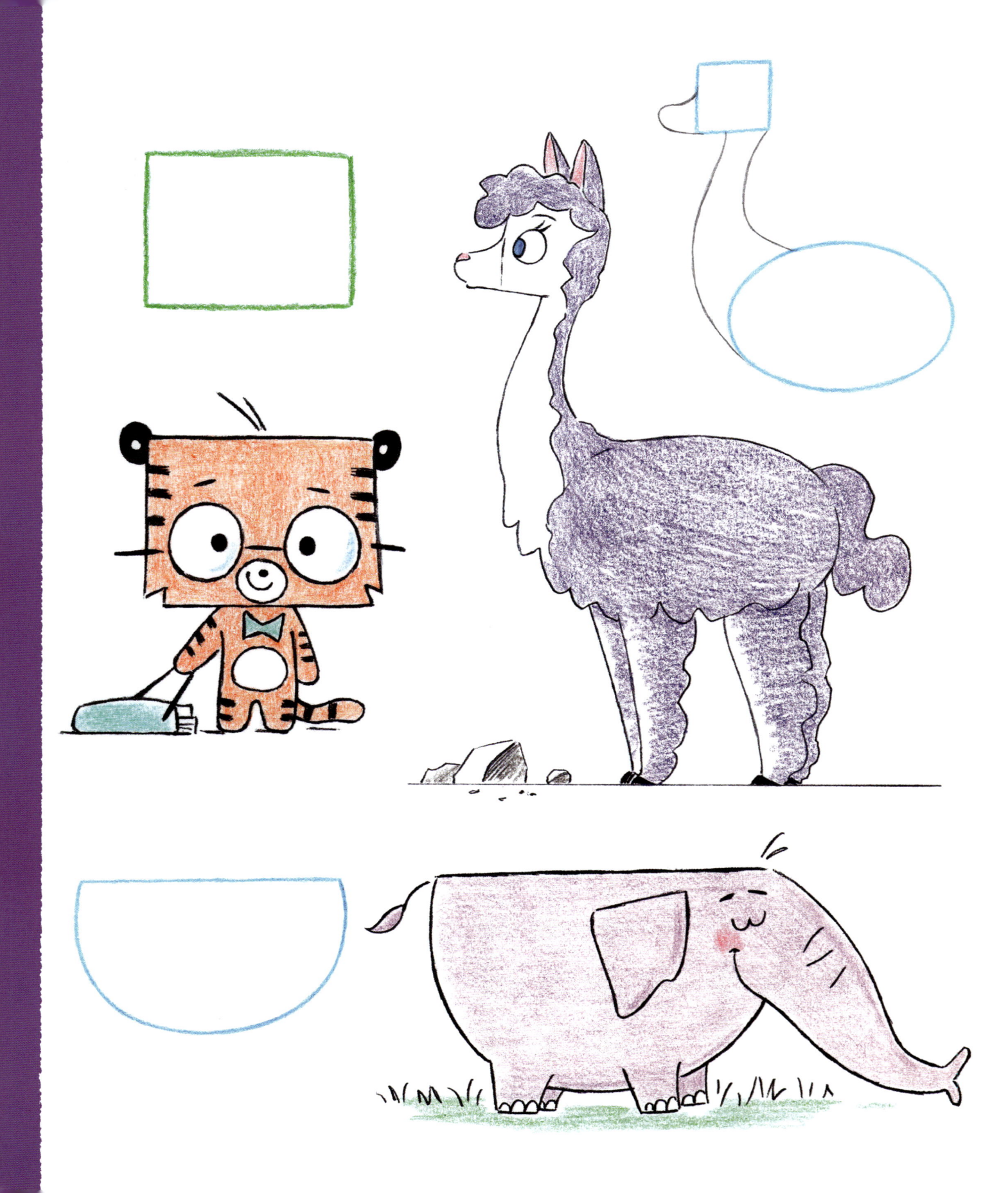

Chapter 1

Let's Get Started!

It's fun to draw—especially when the characters are super cute animals! But where can you find a drawing book like that? Hold on a second! You're already reading it. This book has adorable animals with zillions of easy-to-follow steps. Your family and friends will be impressed by your drawings. And your pet might ask for your autograph.

It ALL Begins with a Circle (or Square, or Triangle...)

Using a technique popular with many cartoonists, we'll start with simple shapes, and build on them step by step until we've got a finished character.

Are you ready for some creative fun?

Then let's take a quick look at the shapes you'll be using.

Circle Oval

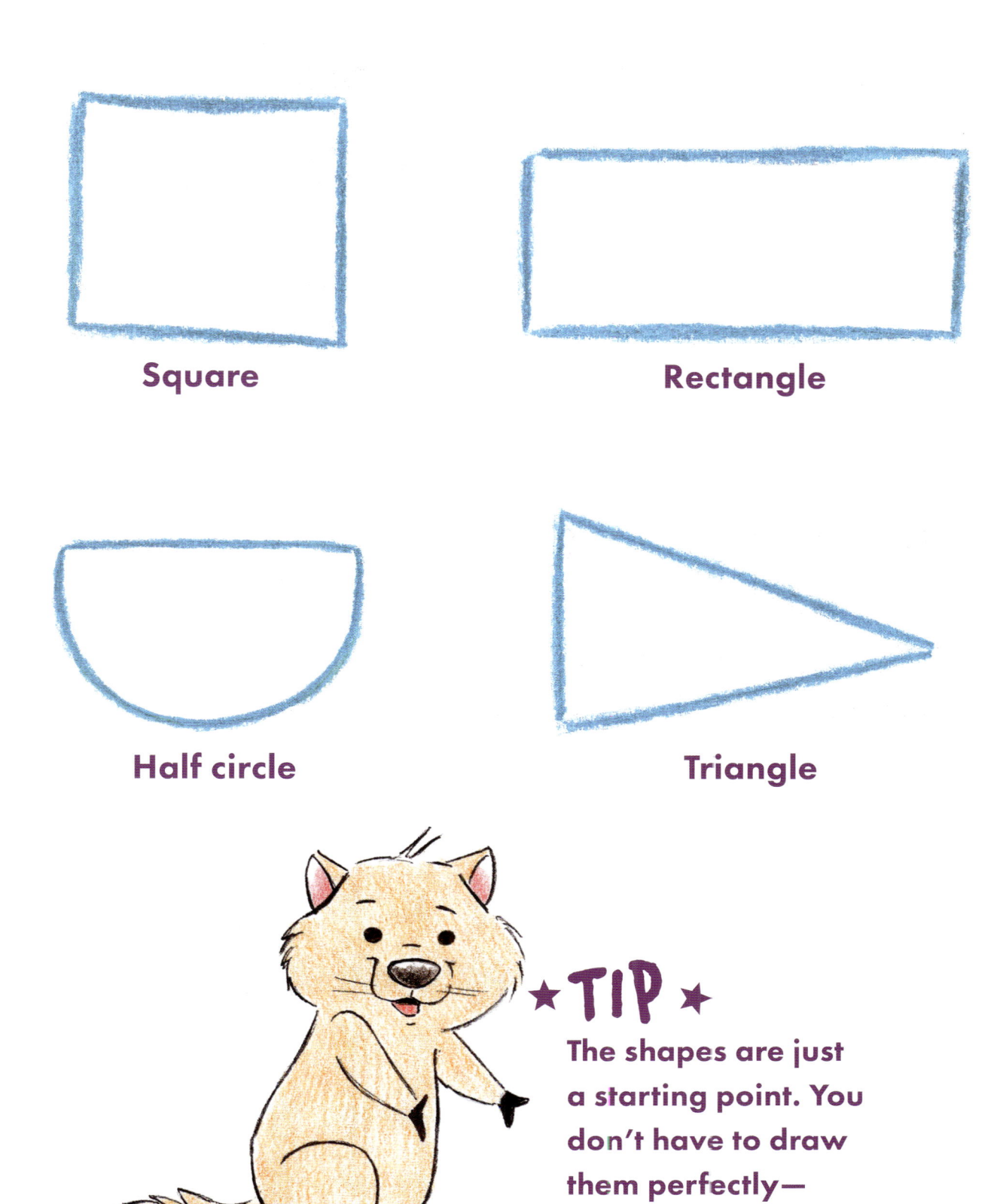

Square

Rectangle

Half circle

Triangle

★**TIP**★

The shapes are just a starting point. You don't have to draw them perfectly—mistakes are allowed!

Now Let's Draw Our Animal!

A circle can be the basis for the head.

A square can also work, like for this elephant.

You can also draw a shape within a shape. This hedgehog's body is an oval—and so is its head!

The half circle is one of my favorite shapes—you might discover your own favorite shape!

The rectangle is great for long bodies.

You can also use shapes for fun details, like triangles for this shark's teeth.

Can you see the shape used to draw this bunny's head? I bet you can!

Chapter 2
Baby Animals & Small Critters

Little animals love to play in the forest. We'll portray that playfulness as we draw them in this chapter.

DRaw all Different types!

Greetings, Artist Friends!

14

The Woodland Slugger

Champion of the Forest

Genius Tiger

Boo-Hoo Bunny

Capybara—Decisions, Decisions!

Mini-Pig

Shy Bear

23

Fennec Fox

Time Out, Little Guy

"Extra Cheese, Please!"

27

Sloth Gets Dizzy Standing Up!

A Talented Chipmunk

FRiENDLY Fox

Raccoon Dog

HMMPH!

Merry Mongoose

Beach Bear

Chapter 3

Big Animals

Big animals are found on every continent. And fortunately we have a shape for every one of them!

Your creativity is as big as the animals in this chapter!

This Way to the Park

40

Bear with a Sweet Tooth

Fluffy Alpaca

44

Dapper Leopard

"He Did It!"

47

BLUSHING ELEPHANT

Something Funny

49

Purple Mane

Black-and-Brown Buck

Super Tall Giraffe

Zebra

The Magic Horn

Making New Friends

Going Whole Hog

Farm Goat

Taking a Drink

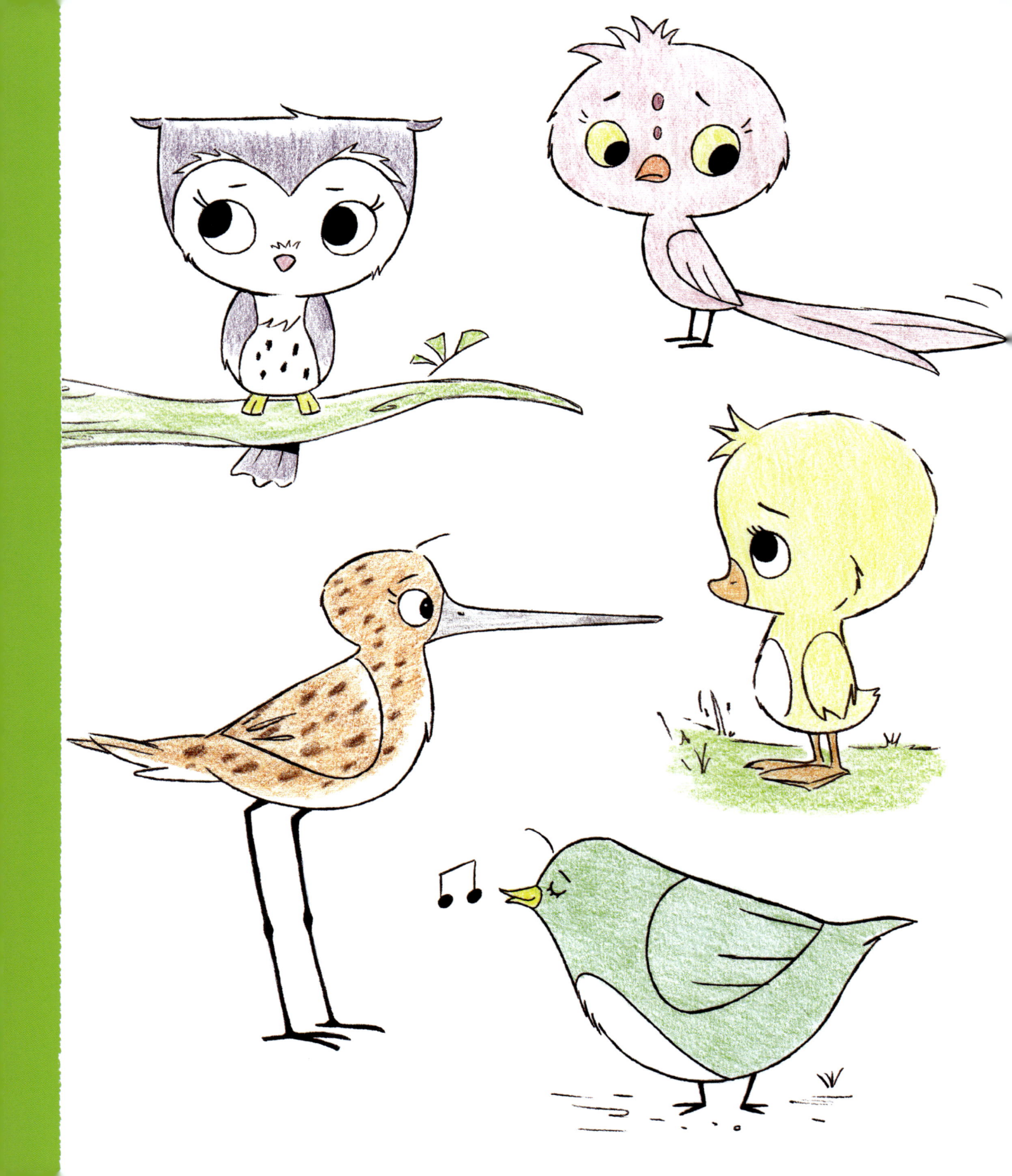

Chapter 4

Birds, Birds, Birds

Did you know there are a zillion types of bird species? We only have enough space to draw half a zillion, but it's the best half.

Let your creativity soar!

Baby Duck

Pocket-Size Owl

67

"I Cleaned My Room!"

CHUNKY BIRD

South for the Winter

71

WooDPecKeR

"I Need to Get That Clipped!"

Penguin Dance Studio

74

Step it up, girls!

75

Musical Bird

Quail

Royal Flycatcher

SandPiper

Me and Mom, Out for a Stroll

"Hey, Where's My Lunch?"

A Very Fuzzy Duckling

First Time Flying Without Mom

Chapter 5

Puppies & Dogs

There are toy dogs, companion dogs, show dogs, and mixed breeds. By changing the shape, you can change the breed of the dog.

I KNOW THE DOGS IN THIS CHAPTER ARE CUTE, BUT TRY NOT TO PET THE ART!

"THROW It Again!"

Cute Smile

Amazing Balance!

The Famous Paw Trick

Corgi

Puppy Loves His New Home

Beagle

Afghan Hound

Look What I Got!

Yuck!

WHERE'D MY BUDDY GO?

101

Chapter 6

Cats & Kittens

Cats come in four basic types: adorable, cranky, mischievous, and even more cranky. To get so much personality into our drawings, we'll use expressions, poses, and props.

ARE YOU READY TO POUNCE INTO THIS CHAPTER?

Oooh, Fun!

LOOKIN' GOOD!

My Dad's the Best!

Hypnotized Kitty

Fancy Cat

109

"It's My First Time Texting!"

Siamese Cat

Winter Kitty

"THIS IS FOR YOU!"

Fashionable Cat

Afraid of the Water

117

Kitten's New Dress!

Cat Walking

Chapter 7

Sea Creatures

Sea creatures are mysterious to us because they live below the water. And we're mysterious to them because we live on land. I don't think we're going to settle this any time soon, so let's draw!

Your drawings will make a splash!

Baby Dolphin Learns to Swim!

"Which Way to the Coral Reef?"

Manatee & Sea Turtle

Hermit Crab

Baby Leopard Seal

OctoPuS on the Go!

ORca Loves Volleyball!

129

Otters Know How to have Fun!

Pretty Fish

Mysterious Squid

133

Mischievous Swordfish

Baby Walrus

135

Blue Whale

Zebra Shark Gets the Joke!

Animals From Down Under

These animals are from Australia and New Zealand. They have odd shapes and curious names. From the super-round wombat to the friendly quokka, they're waiting for you to draw them.

How many of these interesting animals do you know?

Bilby Senses a Snack!

Sugar Glider Takes a Nap

144

Kiwi Bird Gets a Closer Look

Baby Koala

146

147

Numbat Sits Up

148

Quoll Realizes Something

Bongo

Quokka—Famously Cute!

152

Wallaby Gets Ready to Jump!

154

A Very Round Wombat

DunNart

Chapter 9

So Ugly They're Cute!

For this fun section, I've selected kooky looking animals that are so unattractive that they're actually adorable! This includes the star-nosed mole and axolotl, a strange looking salamander with a charming smile!

Drawing is fun and you are doing it!

Star-Nosed Mole

Hyena

Adorable Axolotl

Warthog

Blob Fish

165

Time to Wake up!

Puffer Fish—Ouch!

Timid Possum

Aardvark

Good-Natured Rat

PORCU-PIG

Looking for your favorite character?

Check the alphabetical list to see which page it's on.

About the Author

CHRISTOPHER HART is the world's leading author of art instruction books, with over 8 million copies sold and titles translated into over 20 languages. His books offer aspiring artists accessible and clearly written step-by-step instruction on a wide variety of learn-how-to-draw subjects, including animals, cartoons, manga, and anime.

YOU CAN VISIT CHRIS AT: **ChristopherHartBooks.com**

@Christopher_Hart_Books @ChristopherHart YouTube @chrishartbooks

Discover Christopher Hart's Other How-To-Draw Books for Kids!

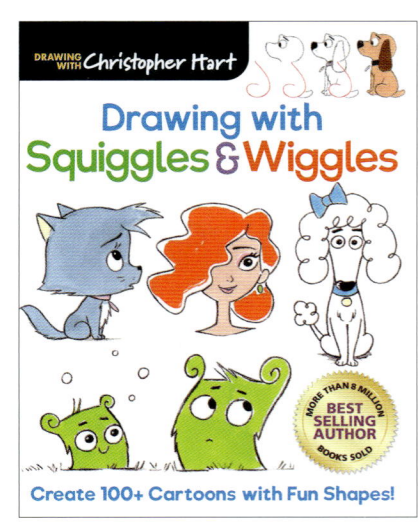